Sage & Smiles

A Book of Poems by
Jet Widick

Handlettering and Illustration by
Kimberly 國子 Taylor-Pestell

To the brightest star in our sky, Lua Belle.
This book is dedicated to you.

ISBN 9781088111925. Hardcover.

Creative direction and design by Kristen Alden

NorthCoast Post, LLC
420 N. Third Street
Marquette, MI 49855

www.northcoastpostmedia.com

THE DIFFERENCE CAN BE ANYTHING

We've all been there... be it a sunrise, a person, an act of kindness, or a shooting star. Miraculous things, things too good to be true, things that make you pause. Yet, they are real, and—presently—it seems our brains *need* to be hyper-focused on what is good, what is genuine, what is joyful. This hope is essential for us to crowd out the buzz of uneasiness that intrudes our tech-filled lives.

Deeply think on this, though: we are truly surrounded each and every day by mountains of goodness. The news is merely a fraction of of our world's overflowing gifts. Jet Widick's *Sage Smiles* envelops us with a gentle reminder that we don't have to look far for things that warm our soul. We can find it in everyday things like nature, a hug, the stars, our favorite keepsake, or a steaming cup of coffee.

I got wrapped up in my favorites in this collection. You will have yours too. The words will find you. Look for calm—not huge—shifts. You will find a catalyst for earnest and intelligent discourse. Jet's words have the efficacy to let the ebb and flow of life's everyday miracles gently seep into you. But mostly, it has the simplest of effects, a contagious smile that will grace your soul. My wishes are *Sage Smiles* for all of Jet Widick's readers.

..

Elizabeth Auckland is a wife, mother of two grown children, a teacher, a believer, and a lover of authenticity. She resides in the beautiful state of South Carolina and is blessed with a brother and four sisters, one of whom shares Sage Smiles with the world.

INTRODUCTION

"Let us create extraordinary words, on condition that they be put to the most ordinary use and that the entity they designate be made to exist in the same way as the most common object."
– Gilles Deleuze

I inherently knew the minute I met the two dynamos Kristen and Kimberly, that we were a triple match made in heaven. My imagined hopes catapulted to the Universe and sweetness manifested through all the hard work, conversations, and creative efforts. The Sage books have been a unique collaboration built on trust in the timing of things—and each other. It has been a remote partnership since 2016, years before the pandemic changed the way we work. All three of us live in different parts of the country and have been working this passion project in and around primary responsibilities and family obligations since we began six years ago.

Something I think is pretty nifty that happened coincidentally, and made aware of in retrospect, is that the first book is Words: speaking up, speaking out, communication, and finding one's voice. The second book is Spirit: our life energy, consciousness and essence. Then you have Smiles, which is associated with happiness, pleasure and true contentment. I love how it is so fitting in sequence like one's own personal growth and self-actualization.

The transformation of my poetry—handwritten by Kimberly, then artistically designed by Kristen—is always a surprise of the good kind. It's like the land of Oz where the door opens, and everything is full of color everywhere. Voilà! It's my favorite part of the process.

I've always felt that being hopeful is one of my strong suits. I have faith that things will work out, embracing first light with daily prayers for goodness all around. That each new day will be lovely. That there will be love, smiles, and truth in all my steps. Optimism is my heartbeat. I see magnificent things ahead—not naïvely, but clearly.

Wise King

You are wise and wonderful
Dynamic and truthful
Gently knows
Real deal glows
Soul brightly shining
This ol' heart of mine
Starts to swell
Grateful for the
Wise King
Who wears it well
Simplicity crown
The right amount of explanations
Gratitude for you celebrations

I love the Sage books and am grateful for the words and spirit behind it all. The whole entire project warms my heart and makes me smile, endlessly.

"No' si volta chi a stella è fisso."
He who is fixed to a star does not change his mind.
– Leonardo da Vinci

Take care and stay at it.

SAGE SMILES

LESS IS MORE

EXCEPT for QUALITY

. . . LIFE'S EXPERTISE

STRONG ATTRIBUTES

high STANDARDS SALUTE

.

EXCELLENCE

PROLIFIC

yummy

. . . . specific

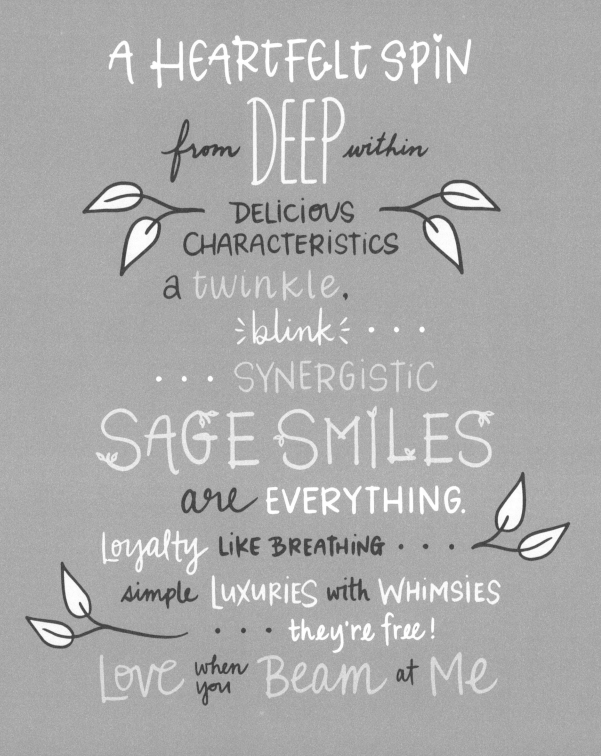

A HEARTFELT SPIN
from DEEP within
DELICIOUS
CHARACTERISTICS
a twinkle,
≻blink≺ . . .
. . . SYNERGISTIC
SAGE SMILES
are EVERYTHING.
Loyalty LIKE BREATHING . . .
simple LUXURIES with WHIMSIES
. . . they're free!
Love when you Beam at Me

Sweet Sips

COFFEE, RUMI, with ME
A FOREVER WARRIOR
WINDOWSILL, FRONT SEAT
START MY DAY with FIRST LIGHT, NEATLY
A POET'S WORDS I SIP ON SWEETLY
REACHING ME, SERENELY
LIVES ON, ENDLESSLY
A QUOTE YOU WANT TO SING
MESSAGES ON ANGEL WINGS

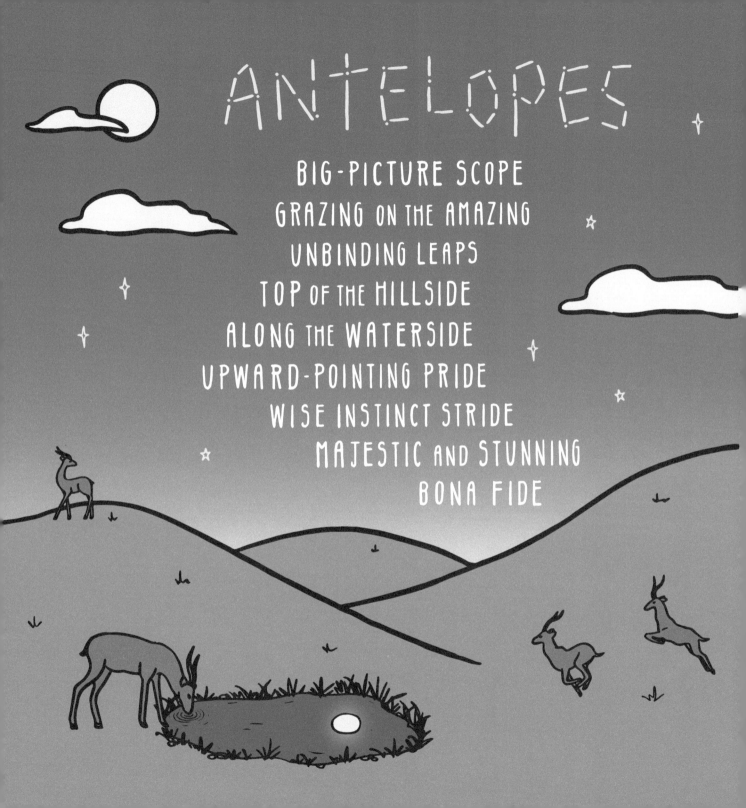

ANTELOPES

BIG-PICTURE SCOPE
GRAZING ON THE AMAZING
UNBINDING LEAPS
TOP OF THE HILLSIDE
ALONG THE WATERSIDE
UPWARD-POINTING PRIDE
WISE INSTINCT STRIDE
MAJESTIC AND STUNNING
BONA FIDE

HOW DO YOU SPELL SUCCESS?

TENDERNESS

YOU MAKE IT LOOK EASY

A SUCCESSION OF GOODNESS

PASSING IT ALONG LIKE THIS

high five THE SKY

BLOW A KISS

DAILY WALK OF LOVE, ENDLESS BENEFITS

giving LIFE GIFTS

journey OF THE ROBUST AND REAL

YOUR SWEETEST DEAL

THE REST IS GRAVY. REWARDS BABY!

INTERSTELLAR

OUR LOVELY SPACE
EXISTS BETWEEN STARS
INTERSTELLAR DUST
MAGNETIC FIELDS MUST
WHERE WE FINALLY MEET
A HELIOPAUSE TREAT
THE SUN'S SOLAR WIND - WIN!
WE ARE UNSTOPPABLE

CHEERS to the WELL-BEING of this DAY
a COFFEE TOAST to the CLEAR THINKING
of YOUR WORKS
SO YOU CAN FLY
AND
CHASE AND BEAR HUG
YOUR DREAMS in the EXPRESS LANE
at YOUR OWN PACE
YOUR SWEET WAY in a WORLDLY VAST ARRAY
of GLORIOUS WONDER
ON THIS EXQUISITE EARTH
this PLACE WE ADORE
to LIVE AND LOVE ...

a FUTURE of WONDER

No WORDS-
FOR HOW HAPPY THIS MAKES ME
I CAN'T THINK OF ONE THING TO SAY
TO SHOW YOU HOW WONDERFUL-
YOU TOOK A REGULAR DAY
AND MADE IT AMAZING
WITH A HOPE THAT MAKES MY HEART SING
STARTED OFF THIS SEASON
A FUTURE OF WONDER
WHERE THE DIFFERENCE CAN BE ANYTHING

KINDNESS ALWAYS

KA...

A SUNSHINE RAY
BRILLIANCE THAT
LIGHTS THE WAY
PRETTY SURE
MAKING SOMEONE'S DAY
LOTS BETTER!
A PEACEFUL AND CALM
MAINSTAY

what is

THERE ARE NO CLASSES TO TEACH *what is*

NEVERTHELESS ~ IT WAS *ingrained* IN ME

STARTING EARLY ~ *love* SHOWN DAILY

WARM-HEARTED *souls*

HUGS *velvety* SOFT AS SUEDE

cozy SWEATER CROCHETED

I TAKE FULL RESPONSIBILITY

sharing THE *love* SHOWN TO ME

BEAUTIES ~ SO GENEROUS ~ GAVE ME *(what is)*

EVERLASTING *tenderness*

Lilies & Roses

WORD BOUQUETS FOR YOU
SWEET SMILES FROM
PETALS BESTOWED
LILY, ROSE-
THE GOOSEBUMPS KNOW
ABSOLUTELY NO WAY
TO CHOOSE A FAVORITE
LOVING BOTH COMPLETELY
UNEQUIVOCALLY
EVERY MINUTE, HOUR, DAILY
FOR ALL ETERNITY

Lovely

I hope your day is Lovely
That you are WELL and HAPPY
Wish I could see you
Instead
I'll imagine you are SMILING
On your morning walk,
SUN-SHINING
Those mountains you're CLIMBING
Quiet and reminding
Of your BRIGHT LIGHT ever guiding

COMMUNITY BRAINS

COMMUNITY OF ARTISTS
PUTTING THEIR HEARTS AND HEADS TOGETHER
TO MAKE LIFE BETTER
WITHOUT A SECOND THOUGHT
AN INFINITE CHAIN OF GOOD
IN THE CREATIVES'
NEIGHBORHOOD
GRACIOUS AND GENEROUS

PULLING EACH OTHER UP ♥ SO HAPPY TO HAVE A CUP

THANK YOU
FOR SHARING

YOUR LOVE
AND CARING

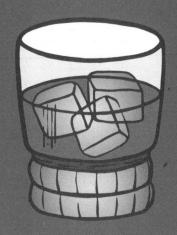

SOLID as a ROCK TUMBLER

Saved from our Cuba trip
As we tumble broken glass
From a cracked compass
While boats pass
Cohibas
So good, should be illegal
Warm evening, tumbler cup
Rock solid, filled up

ABOUT

JET WIDICK

Jet Widick is a writer, poet, and mother of two adult sons. A passionate explorer of inner and outer nature, her books are full of warmth, conscience, fortitude and whimsy, and cover a range of topics that reflect the lovely little things that make up our everyday lives—which so often go unnoticed—yet are truly the most important ones of all.

www.jetwidick.com

. .

KIMBERLY 図子 TAYLOR-PESTELL

Kimberly Kuniko is the Nikkei American hapa artist and designer behind Lacelit, a paper goods company featuring endearing illustration, sentimental turns of phrase, and clever wordplay. She also loves exploring collage and mixed media art journaling and hosting cozy, virtual Guided Creative Retreats for creatives of all mediums that foster creativity, imagination, and storytelling in all its forms. She resides in what is now known as Monrovia, California, with her husband and their calico tabby cat.

www.lacelit.com

. .

kristen alden

Kristen Alden is a writer, visual artist, and graphic designer with a passion for bringing creative ideas to life. After a few years on the West Coast and a couple more in the Upper Peninsula of Michigan, she now spends her time down south developing a vision for the everyday and an organized way of making things more beautiful.

www.kristenalden.com

THANK YOU.

Gentle ways to show appreciation
Discipline and imagination
Pure elation
God's creation

Printed in the USA
CPSIA information can be obtained
at www.ICGtesting.com
LVHW061351261023
761446LV00007B/95